GAY ROBINS

EGYPTIAN STATUES

SHIRE EGYPTOLOGY

Cover photographs
(Left) Colossal statue of King Amenhotep III, quartzite, Eighteenth Dynasty, funerary
temple of Amenhotep III at Thebes.
(Top right) Colossal statues of King Ramesses II, sandstone, Nineteenth Dynasty, temple
of Ramesses II at Abu Simbel, Nubia.
(Bottom right) Colossal statues of various kings in front of the eighth pylon at the temple
of Karnak, limestone and quartzite, Eighteenth Dynasty, Thebes.
(Author's photographs)

This book is dedicated to the memory of my beloved husband, Charles Shute, who
saw its beginning but not its end.

British Library Cataloguing in Publication Data:
Robins, Gay
Egyptian Statues. – (Shire Egyptology; no. 26)
1. Statues – Egypt
2. Sculpture, Ancient – Egypt
1. Title
731.7'6'0962
ISBN 0 7478 0520 2.

Published by
SHIRE PUBLICATIONS LTD
Cromwell House, Church Street, Princes Risborough,
Buckinghamshire HP27 9AA, UK.
Website: www.shirebooks.co.uk

Series Editor: Barbara Adams

Number 26 in the Shire Egyptology Series.

ISBN 0 7478 0520 2.

First published 2001.

Printed in Great Britain by
CIT Printing Services Ltd, Press Buildings,
Merlins Bridge, Haverfordwest, Pembrokeshire SA61 1XF.

Contents

Acknowledgements

I would like to thank Peter Lacovara, Dorothea Arnold, Catharine Roehrig, Eileen Sullivan and Mary Doherty for all their help with the illustrations, Glenn Gunhouse for reading the manuscript and making many valuable suggestions, and Brian Winterfeldt for his generous support of my work.

4

List of illustrations

Chronology

Early Dynastic Period	3050–2686 BC
	3050–2890 Dynasty I *Den*
	2890–2686 Dynasty II *Khasekhem(wy)*
Old Kingdom	2686–2181 BC
	2686–2613 Dynasty III
	2668–2649 Djoser
	2613–2498 Dynasty IV
	2566–2558 Djedefre
	2558–2528 Khaefre
	2525–2497 Menkaure
	2498–2345 Dynasty V
	2477–2467 Neferirkare
	2345–2181 Dynasty VI
	2332–2283 Pepi I
	2278–2184 Pepi II
First Intermediate Period	2181–2040 BC
	2181–2040 Dynasties VII–X
	2134–2040 Dynasty XI (Theban)
	2060–2040 Nebhepetre Mentuhotep
Middle Kingdom	2040–1782 BC
	2040–1991 Dynasty XI (all Egypt)
	2040–2010 Nebhepetre Mentuhotep
	1991–1782 Dynasty XII
	1881–1842 Sesostris III
Second Intermediate Period	1782–1570 BC
	1782–1650 Dynasties XIII–XIV
	1663–1555 Dynasties XV–XVI (Hyksos)
	1663–1570 Dynasty XVII (Theban)
New Kingdom	1570–1070 BC
	1570–1293 Dynasty XVIII
	1498–1483 Hatshepsut
	1504–1450 Tuthmosis III
	1453–1419 Amenhotep II
	1386–1349 Amenhotep III

1350–1334 Akhenaten
1334–1325 Tutankhamun
1321–1293 Horemheb
1293–1185 Dynasty XIX
1279–1212 Ramesses II
1212–1199 Merneptah
1199–1193 Seti II
1185–1070 Dynasty XX

Third Intermediate Period 1070–713 BC
1070–945 Dynasty XXI
945–712 Dynasty XXII
828–712 Dynasty XXIII
724–713 Dynasty XXIV
772–712 Dynasty XXV/1

Late Period 713–332 BC
713–656 Dynasty XXV/2
664–525 Dynasty XXVI
664–610 Psammetichus I
525–404 Dynasty XXVII
404–399 Dynasty XXVIII
399–380 Dynasty XXIX
380–343 Dynasty XXX
360–342 Nectanebo II

Ptolemaic Period 332–30 BC

Roman Emperors 30 BC – AD 395

1
Introduction

For over three thousand years ancient Egyptian sculptors created statues of deities, kings and members of the governing elite group. Statues were not made as isolated objects to be viewed as works of art – as we view them today in museums and art books – but were produced for a specific setting in a temple or tomb, where they played a vital role in temple or funerary ritual. Most statues were places where a non-physical entity – a deity, the royal *ka*-spirit, or the *ka*-spirits of the dead – could manifest in this world. The statue provided a physical body and had to be recognisable and appropriate to the being that was meant to manifest in it. Since such beings were not physical entities, they were unrestricted by time and space and could be simultaneously present in all their images wherever they were located. Most statues formed a ritual focal point. Offerings were made to them, or rather to the being inhabiting them, incense was burned before them, and the correct words were recited and actions performed. In order for a statue to function in this way, it had to undergo the opening of the mouth ritual, which vitalised it and enabled it to house the being it represented. The burning of incense was important because the word for 'incense', *senetjer*, also meant 'to make divine'.

Egyptian society was hierarchically structured with the king at the top, followed by the different ranks of elite government officials and their families, and finally the non-elite, who provided services and food for the elite. Although the non-elite formed at least 95 per cent of the population, we know little about them, since they have left no written records nor any representations of themselves. What we today regard as Egyptian art, including statues, was commissioned by the king and the elite and mainly represented the king, the elite and deities. In the Old and Middle Kingdoms, statuettes and models showing the activities of non-elite servants and peasants were included in elite burials, but these were commissioned by the elite to serve the needs of the elite.

The king, with all the resources of his office, was by far the largest commissioner of statues – at least a thousand monumental statues of Amenhotep III are still known today. Even the most important officials came nowhere near the king, although they might commission a number of statues for themselves and members of their families. Lower-ranking officials could probably afford only one or two statues, and these were often run of the mill or even mediocre in quality. Nevertheless, statues were more prestigious than the cheaper, two-dimensional relief-cut stone stelae that were often the only monuments that the lowest members

of the elite could afford. Size, material and quality of workmanship all played a role in signifying the status of the person represented by a statue.

2
Materials and techniques

Statues, like most artistic production in ancient Egypt, were made in workshops, where artists worked in teams overseen by master sculptors. The main materials used in the manufacture of statues were stone, wood and metal. Because of the different techniques involved, individual workshops would probably have specialised in a particular material.

The majority of surviving statues are made of stone, of which there was a plentiful local supply. The cliffs that border the Nile valley are mainly limestone, but in some places sandstone is exposed, while at Aswan granite and granodiorite predominate. Other available stones included greywacke (schist), steatite, calcite, quartzite, diorite, basalt, serpentine and dolorite.

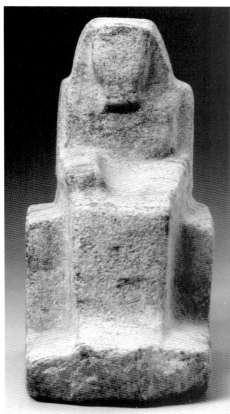

A statue began as a rectangular block of stone slightly larger than the desired size of the finished object. Front and back views of the image were sketched out on the front and back of the block, while profile images were drawn on each of the sides. From the Middle Kingdom on, these outlines were probably laid out on a squared grid (known to have been used in two-dimensional art) that ran all the way around the block so as to ensure that all the sketches matched up. Sculptors then cut away the stone on all four sides

1. Unfinished statuette of Menkaure, granodiorite, Fourth Dynasty, pyramid complex of Menkaure at Giza, height 35.2 cm. (Harvard University Museum of Fine Arts Expedition. 11.730. Courtesy, Museum of Fine Arts, Boston. Reproduced by permission. © 2000 Museum of Fine Arts, Boston. All rights reserved.)

and the top around the sketched outline until they achieved the rough shape of the statue. As they cut the sketch and grid away with the stone, they would re-mark important levels and points with lines or dots of paint. Once they had the outline of the statue shaped, they could concentrate on modelling the face and body, and executing the details of costume and other accoutrements (figure 1). The eyes were often inlaid with white and black stones, such as calcite and obsidian, and might be surrounded by a copper rim.

Soft stones, such as limestone and sandstone, could be worked with copper tools, such as chisels. However, these tools alone were incapable of making an impression on the harder stones. These had to be worked by hammering with still harder stones and by using a quartz abrasive, supplied by sand from the desert. From early on Egyptian stoneworkers had learned how to use drills with copper bits in conjunction with an abrasive in order to make hard-stone vessels. It is the abrasive, not the drill bit, that cuts the stone.

Soft-stone statues were finished by smoothing, plastering and painting, using the same pigments, techniques and colour conventions employed in painted relief and flat painting (figure 2). Pigments were made from naturally occurring minerals: for example, white from calcium carbonate

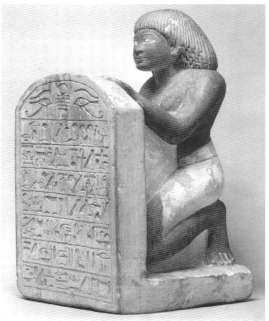

2. Kneeling stelophorous statue of the official Roy, painted limestone, Eighteenth Dynasty, height 31.5 cm. (Courtesy of the Metropolitan Museum of Art, New York, Gift of J. Pierpont Morgan, 1917.) (17.190.1960)

3. Standing statue of a god, granodiorite, Eighteenth Dynasty, reign of Amenhotep III, probably from the funerary temple of Amenhotep III at Thebes, height 91.8 cm. (Courtesy of the Metropolitan Museum of Art, New York, Rogers Fund, 1919.) (19.2.15) (The Metropolitan Museum of Art, Fletcher Fund, 1996.) (1996.362)

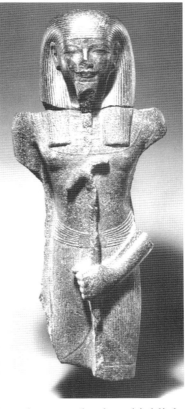

(whiting) or calcium sulphate (gypsum); black from carbon (mostly soot or charcoal); shades of yellow, red and brown from ochre (iron oxide); and green from malachite. Blue was most commonly derived from an artificial compound made by heating together silica (probably in the form of quartz), a copper compound (probably malachite), calcium carbonate and natron. Pigments were prepared by grinding them on a hard-stone mortar, and applied by mixing them with a medium, such as plant gum or animal glue, so as to attach them to the plastered surface of the statue.

There is some evidence that paint and gilding could be applied to hard-stone statues. In some examples, clothing and insignia were painted, while the skin was left the colour of the bare stone. In others, the paint may have been used only to highlight details, since the surface of the stone was otherwise finished with a high polish, or made to exhibit a deliberate contrast between highly polished areas and unpolished ones (figure 3). In addition, many hard stones were probably chosen for the significance of their colours. Red granite and brown, yellow, red and purple quartzite had solar connections, while black stones were associated with the fertility of the black Nile silt and the regenerative properties of the underworld and its ruler, Osiris. Small steatite statues, common for instance in the reign of Amenhotep III, were not painted but glazed blue or turquoise. The shiny, reflective surface of the glaze was associated with the brilliance of the sun.

Most formal stone statues, that is those representing deities, the king and the elite, recall the shape of the original block of stone, so that the

4. Kneeling statuette of King Amenhotep II, limestone, Eighteenth Dynasty, Deir el-Medina, Thebes, height 30 cm. (Courtesy of the Metropolitan Museum of Art, New York, Rogers Fund, 1913.) (13.182.6)

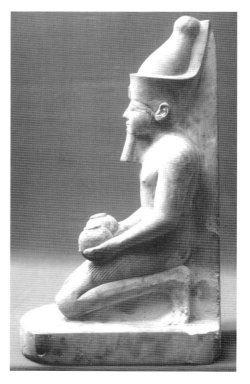

resulting statues are strongly rectilinear. Furthermore, the stone was usually not cut away between the arms and the body, and between the legs in standing figures and the legs and the seat in seated figures, and items do not stick out from the body. For instance, in two-dimensional images of officials, the official carries a long staff held ahead of the body in one hand and a sceptre in the other. These could be replicated in wooden statues, but in stone statues both arms were held close to the sides of the body with the hands clenched, and the staff and sceptre omitted. Stone statues also usually have a wide, rectilinear back slab or a narrower back pillar (figures 4 and 9).

The fact that formal stone statues were rarely fully freed from the original stone block from which they were cut gives an impression of solidity, strength and power. While this may have been partly symbolic, it was also practical in helping to protect the statue from accidental damage and breakage. The reason why so many statues have broken noses is precisely because this feature projects from the surface of the statue. In the same way, the projecting head of the royal cobra worn on the king's forehead has often been broken off.

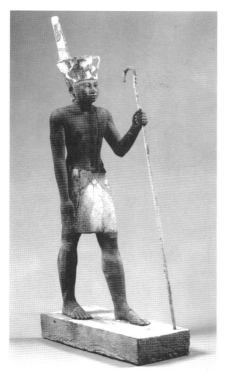

5. Standing statuette of a king, painted cedar, Twelfth Dynasty, Lisht, height 58 cm. (Courtesy of the Metropolitan Museum of Art, New York, Museum Excavations 1913–14; Rogers Fund supplemented by Contribution of Edward S. Harkness.) (14.3.17)

Wooden statues were already being produced in the Early Dynastic Period, but they have survived less well than stone ones because wood is subject to decay and the depredations of insects. Wood was provided by native Egyptian trees, such as acacia, tamarisk and sycamore fig, which produce relatively small, irregularly shaped pieces of wood. Better-quality timber was imported from the coniferous forests of Syria, but this was probably available only to the king and wealthy upper elite.

The wood was worked with copper or, from the Middle Kingdom, bronze saws and adzes. The head, torso, legs and back part of the feet were normally cut in one piece that included pegs beneath the heels which slotted into a separate statue base. The front part of each foot was commonly made independently. Each arm was usually made from a separate piece of wood that was then attached to the torso by a peg. Unlike stone statues, the arms could be held away from the body and could be bent. Objects such as staffs and sceptres were made separately and slotted through clenched hands, which were worked with a hole through the middle. Wooden statues do not usually have back slabs or pillars (figure 5).

Like soft-stone statues, wooden statues were normally covered with a layer of plaster and painted; sometimes the paint was applied directly to high-quality wood. This process hid the joints at the shoulders and on the feet, but today these are often exposed owing to the deterioration of the paint and plaster over time (figure 5). In some statues, the eyes were inlaid.

Metal statues included figures made out of gold and silver (figures 6 and 7), but most of those that survive today are made of bronze (figure 8). True bronze (copper and tin) was introduced during the later Middle Kingdom. Before that, arsenic bronze (copper and arsenic) was used in the early Middle Kingdom; in the Old Kingdom copper alone was used. Statues were cast by the lost-wax technique, already known in the Old Kingdom and well developed by the Middle Kingdom. In the case of

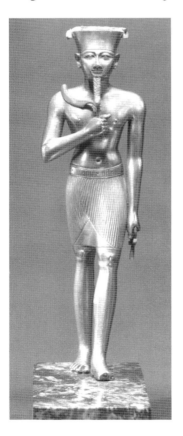
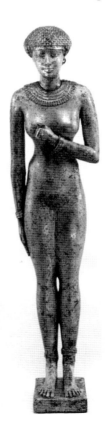

6. (Far left) Standing statuette of the god Amun, gold, Twenty-second Dynasty, height 17.5 cm. (Courtesy of the Metropolitan Museum of Art, New York, Gift of Edward S. Harkness, 1926.) (26.7.1412)

7. (Left) Standing statuette of a woman, silver, Twenty-sixth Dynasty, height 24 cm. (Courtesy of the Metropolitan Museum of Art, New York, Bequest of Theodore M. Davis, 1915. The Theodore M. Davis Collection.) (30.8.93)

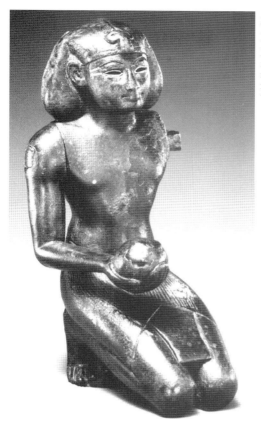

8. Kneeling statuette of King Tuthmosis III, bronze with gold inlay, Eighteenth Dynasty, height 13.5 cm. (Courtesy of the Metropolitan Museum of Art, New York, Purchase, Edith Perry Chapman Fund and Malcolm Hewitt Wiener Foundation, Inc. Gift, 1995.) (1995.21)

small statues, the image was first made in wax, around which a layer of clay was pressed in order to take up the shape and all the details of the wax image. This was then heated to bake the clay and melt the wax, leaving a hollow mould into which molten metal could be poured. After the metal had cooled, the mould was broken away to reveal the statue. For larger statues, the Egyptians usually used core casting. This is basically the same as the lost-wax method except that the wax is modelled round a clay or sand core. When the clay is placed around the wax to form the mould, pins are pushed through from the outside into the core so that when the wax is melted the core remains in position. Metal is then poured into the space between the outer mould and the inner core. When the metal has cooled, the mould is broken away and as much of the core as possible is removed. The process thus produces a hollow

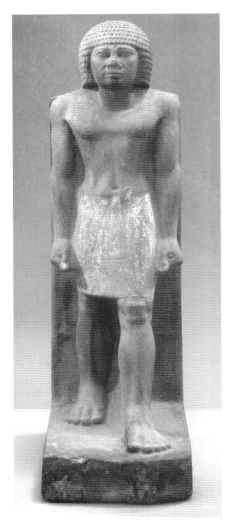

9. Standing statue of an official, painted quartzite, Fourth Dynasty, probably from el-Kab, height 89.5 cm. (Courtesy of the Metropolitan Museum of Art, New York, Harris Brisbane Dick Fund, 1962.) (62.200)

statue and saves on the amount of metal used. As with wooden statues, the various parts of metal figures were often made separately and pegged together, and the arms, for instance, may be held away from the body and separate objects carried. Complex compositions can include separately cast items that are pegged to the main figure or slotted through the hollows of the clenched hands. The metal was not painted, but it could be engraved with designs or inlaid with precious stones, as in cult statues, or with other metals, as was common in the best work of the Third Intermediate and Late Periods.

In addition to cast-metal statues, other statues were made by wrapping sheet metal around a wooden image, which had been produced in the same way as a wooden statue. The sheets of metal were moulded around the core image, and details were then incised into the metal. This technique was used, for instance, to make the gold royal and divine statues found in the tomb of Tutankhamun.

One characteristic that all formal statues have in common, whatever their material, is what is known as 'frontality'. This means that they face straight ahead and do not bend, turn or twist the body or head to any marked degree (figure 9). Because this is such a contrast to classical Greek statuary, once considered the epitome of sculpture in the round, frontality was at one time regarded as an unfortunate shortcoming arising

from the technical inadequacies of the Egyptian sculptors. In fact, informal statues representing non-elite servant figures, such as servant statuettes from the Old Kingdom, or New Kingdom cosmetic items that incorporate figures of servants, show that sculptors were perfectly capable of rendering the human figure in other poses. The servant figures bend or squat to accomplish their various tasks and, in contrast to most formal figures, their bodies and limbs are fully released from the stone. In the New Kingdom figures, the body often twists or bends to balance the weight of a jar carried on the hip, shoulder or head (figure 10). Frontality, therefore, has little to do with the technical abilities of

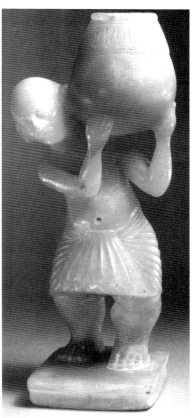

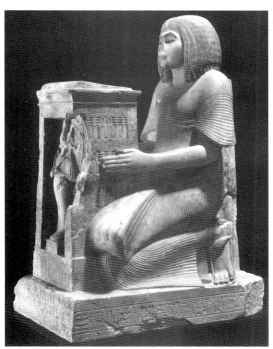

10. (Above) Dwarf with cosmetic pot, calcite, Eighteenth Dynasty, height 19.5 cm. (Courtesy of the Metropolitan Museum of Art, New York, Gift of J. Pierpont Morgan, 1917.) (17.190.1963)

11. (Left) Kneeling statue of the official Iuny with shrine containing an image of Osiris, limestone, Nineteenth Dynasty, tomb at Asyut, height 129 cm. (Courtesy of the Metropolitan Museum of Art, New York, Rogers Fund, 1933.) (33.2.1)

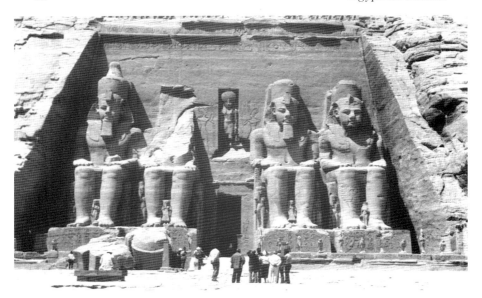

12. Colossal statues of King Ramesses II, sandstone, Nineteenth Dynasty, temple of Ramesses II at Abu Simbel, Nubia. (Author's photograph.)

sculptors but is rather the mark of a formal statue and is related to its function. Placed in a rectangular shrine or in an enclosed room (*serdab* = Arabic for 'cellar') with the opening to the front, before which rituals were performed, the statue could not effectively face in any other direction than forwards (figure 11). The being manifest in the statue and the performer of the ritual thus faced each other and could interact. The same frontal characteristic was also ideally suited to statues in an architectural context, placed in front of a temple pylon, or in front of or between pillars or columns (figures 12 and 36).

3
Poses and statue types

Statues of deities

The basic poses of formal statues were limited to standing, seated or kneeling. Deities usually stand or sit. Standing statues of gods are either shown with the left leg well advanced (figure 6) – the normal male pose – or they are mummiform with their feet together, as though wrapped in a shroud (figure 13). The most common mummiform god is Osiris, ruler of the underworld, but Ptah, god of Memphis, Khonsu, the child god of Thebes, and the ithyphallic Min of Koptos are also mummiform. Standing statues of goddesses are usually shown with the left foot placed only slightly forward so that the heel overlaps the toes of the right foot – the normal female standing pose. Female deities are rarely shown as mummiform.

Seated deities sit on a throne (figure 14). From the Eighteenth Dynasty, goddesses such as Renenutet, the harvest goddess, were sometimes shown suckling a child. This type of image became extremely popular in the first millennium BC, when the goddess was usually Isis suckling the infant Horus (figure 15). Deities may also appear in pair or group statues, either with other deities – for instance, consorts such as Amun and Mut of Thebes often appear together – or with the king. Deities do not normally kneel, since kneeling implies deference in the presence of a being of higher status. In the Late and Ptolemaic Periods, wooden statues of Isis and Nephthys, placed in the burials of the elite, kneel in mourning because the body of the deceased was identified with the god Osiris. Deities can also appear completely in animal form – for instance, Hathor as

13. Standing statuette of the god Osiris, bronze with gilding and engraved decoration, Late Period, height 25.5 cm. (Courtesy of the Metropolitan Museum of Art, New York, Harris Brisbane Dick Fund, 1956.) (56.16.2)

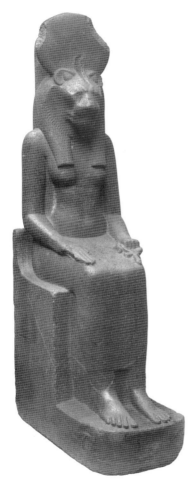

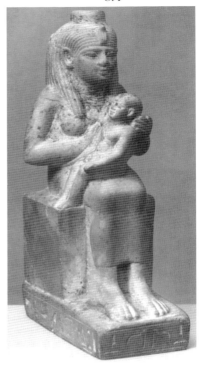

14. (Left) Seated statue of the goddess Sekhmet, granodiorite, Eighteenth Dynasty, reign of Amenhotep III, temple of Mut at Karnak, Thebes, height 210 cm. (Courtesy of the Metropolitan Museum of Art, New York, Gift of Henry Walters, 1915.) (15.8.2)

15. (Above) Statuette of the goddess Isis and her son Horus, stone, Late Period, height 14.5 cm. (Courtesy of the Metropolitan Museum of Art, New York, Rogers Fund, 1945.) (45.2.10)

a cow, Renenutet as a cobra, or Horus as a falcon. Sometimes the animal protects a small image of the king (figure 16).

Statues of kings

Although no standing statues of kings survive from the Early Dynastic Period, representations of such images are known from both the First and Second Dynasties. Standing statues show the king either in the normal male pose with his left leg well advanced (figure 17) or with his

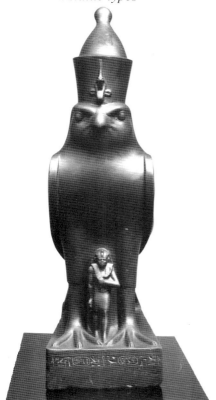

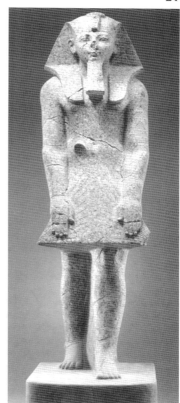

16. (Above left) Statue of the god Horus as a falcon protecting King Nectanebo II, schist, Thirtieth Dynasty, height 72 cm. (Courtesy of the Metropolitan Museum of Art, New York, Rogers Fund, 1934.) (34.2.1)

17. (Above right) Standing statue of King Hatshepsut, red granite, Eighteenth Dynasty, funerary temple of Hatshepsut at Deir el-Bahri, Thebes, height 280.5 cm. (Courtesy of the Metropolitan Museum of Art, New York, Museum Excavations, 1927–8.) (28.3.18)

feet together in the 'mummiform' pose (figure 18). The first is an active image referring to the king's role as the performer of ritual and the aggressive keeper of cosmic order. In stone statues, he normally holds his arms by his sides with his hands clenched. In a variant pose, known from the Twelfth Dynasty on, the hands are placed palm down against the royal kilt, a gesture that indicates the king is adoring a deity (figure 17). 'Mummiform' figures of the king are often shrouded like the mummified Osiris, but in other examples, although the king's feet are

22

placed together, the figure is not shrouded but wears the *sed*-festival robe or the royal kilt (figure 18). This pose is a passive one – Osiris himself is a somewhat inactive deity to whom things are done by others – and it is often found in architectural contexts where statues are placed against or between pillars.

Seated statues show the king enthroned (figure 19). The earliest surviving examples are two statues of the Second Dynasty king Khasekhem, found in the temple at Hierakonpolis. A statuette of Pepi I of the Sixth Dynasty shows him kneeling offering two jars, but this pose is rare in surviving royal statues until the Eighteenth Dynasty (figure 4). Kneeling statues imply that the king is a worshipper or supplicant in the presence of a god. A kneeling statue of King Horemheb, discovered in 1989 buried with a

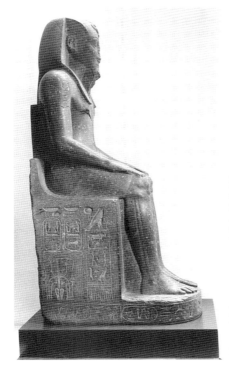

18. (Above) Standing statue of King Nebhepetre Mentuhotep, painted sandstone, Eleventh Dynasty, funerary temple of Nebhepetre Mentuhotep at Deir el-Bahri, Thebes, height 252 cm. (Courtesy of the Metropolitan Museum of Art, New York, Museum Excavations, 1923–4; Rogers Fund, 1922.) (26.3.29)

19. (Left) Seated statue of King Amenhotep III, porphyritic diorite, Eighteenth Dynasty, temple of Luxor at Thebes, height 255 cm. (Courtesy of the Metropolitan Museum of Art, New York, Rogers Fund and Gift of Edward S. Harkness, 1921.) (22.5.1.)

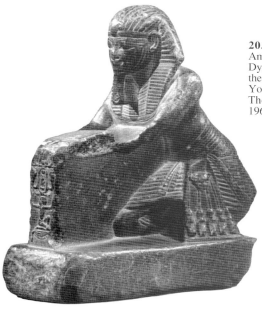

20. Kneeling statuette of King Amenhotep III, serpentine, Eighteenth Dynasty, height 14 cm. (Courtesy of the Metropolitan Museum of Art, New York, Purchase, Fletcher Fund and The Guide Foundation, Inc. Gift, 1966.) (66.99.28)

number of statues in the temple of Luxor, was found to have been slotted into a large stone base that also held a seated statue of the god Atum. The resulting group showed Horemheb kneeling, offering two jars to the seated Atum, who faced him. Metal figures of kings attached to ritual furniture also often kneel for the same reason (figure 8). Most kneeling statues show the king with his legs side by side and his body held vertically. From the later Eighteenth Dynasty, the king is also shown in a kneeling pose that comes halfway towards prostration: one leg is stretched out behind and his body is bent forward as he presents an offering (figure 20).

Pair and group statues of kings and deities are known from the Old Kingdom on. In some, all the figures are on the same scale and in the same pose, either standing or seated. In others, the deity sits and the king, on a smaller scale, stands, so that the king is under the protection of the deity.

A seated statue of King Djedefre of the Fourth Dynasty shows a small female figure – probably his wife – seated on the ground by his leg. Small figures of royal women also stand by the lower legs of Middle and New Kingdom kings' statues (cover). Pair statues may also show the king and his wife or mother seated or standing together on the same scale. Statues of royal women, normally the king's mother or the king's principal wife, occur alone. They normally depict the subject seated or, less often, standing.

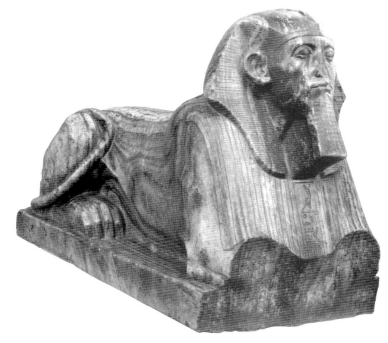

21. Sphinx statue of King Sesostris III, diorite, Twelfth Dynasty, height 42.5 cm. (Courtesy of the Metropolitan Museum of Art, New York, Gift of Edward S. Harkness, 1917.) (17.9.2)

The king also appears in the form of a sphinx, normally with a lion's body and a human head (figure 21). The most famous example is the Fourth Dynasty sphinx on the Giza plateau, originally representing King Khaefre.

Statues of the elite

Statues of elite men and women occur in both standing and seated poses. When standing, men advance their left leg, whereas women have their feet closer together in a less active pose (figure 22). In wooden statues, men hold a staff in one hand and a sceptre in the other, denoting the concept of authority (figure 22). In stone statues, their arms are held by their side with fists clenched (figure 9). Women, by contrast, hold their hands open (figure 22). From the Old Kingdom to the New Kingdom, husband and wife pair statues – seated or standing – are common, often with smaller figures of children included (figure 23). Similar pair statues sometimes show the man not with his wife but with

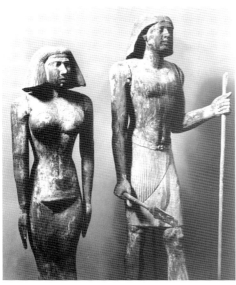

22. Standing statues of the official Merti and his wife, painted wood, Fifth Dynasty, Saqqara, heights 148 and 133 cm. (Courtesy of the Metropolitan Museum of Art, New York, Rogers Fund, 1926.) (26.2.2 & .3)

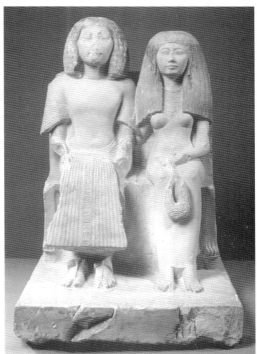

23. Seated pair statue of the official Iuny and his wife Renenutet, painted limestone, Nineteenth Dynasty, tomb at Asyut, height 84.5 cm. (Courtesy of the Metropolitan Museum of Art, New York, Rogers Fund, 1915.) (15.2.1)

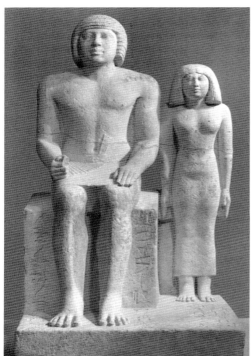

24. Pair statue of the official Demedji and his wife Henutsen, painted limestone, Fifth Dynasty, height 83 cm. (Courtesy of the Metropolitan Museum of Art, New York, Rogers Fund, 1951.) (51.37)

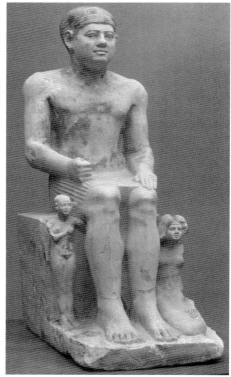

25. Seated statue of Nikare with his wife and daughter, painted limestone, Fifth Dynasty, height 57 cm. (Courtesy of the Metropolitan Museum of Art, New York, Rogers Fund 1952.) (52.19)

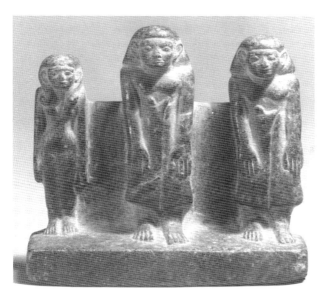

26. (Left) Group of two men, Tjeniwen and Sobekaa, and a woman, Tiw, black stone, Middle Kingdom, height 7.9 cm. (Courtesy of the Metropolitan Museum of Art, New York, Purchase, Fletcher Fund and The Guide Foundation, Inc. Gift, 1966.) (66.99.9)

27. (Right) Standing statue of the official Horbes holding a figure of Osiris, schist, Twenty-sixth Dynasty, temple of Karnak at Thebes, height 61.5 cm. (Courtesy of the Metropolitan Museum of Art, New York, Rogers Fund, 1919.) (19.2.2)

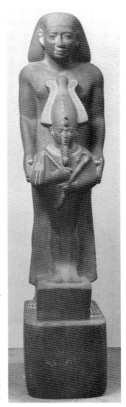

his mother. In the Old Kingdom, the poses of the man and woman may differ. In some statues, the husband is seated – the more prestigious pose – and the wife, shown on a smaller scale, stands beside him (figure 24). In others, the wife is depicted as a miniature figure standing or squatting by her husband's leg (figure 25). After the Old Kingdom, the wife in elite statues is rarely depicted in miniature form. In the Twelfth and Thirteenth Dynasties, larger family groups of three, four or five figures become fairly common (figure 26). New Kingdom pair statues more usually show the figures seated rather than standing. After the New Kingdom, pair statues become rare, perhaps because their association is with tombs, while most statues were now dedicated in temples. At the same time, standing statues of men are frequently shown presenting images of deities (figure 27).

Scribe statues show male officials seated cross-legged on the ground with their kilts stretched taut across the legs. On this surface they unroll a papyrus

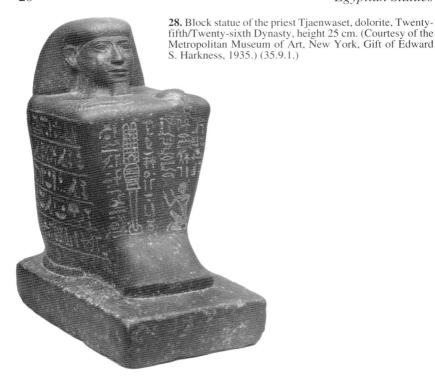

28. Block statue of the priest Tjaenwaset, dolorite, Twenty-fifth/Twenty-sixth Dynasty, height 25 cm. (Courtesy of the Metropolitan Museum of Art, New York, Gift of Edward S. Harkness, 1935.) (35.9.1.)

scroll and either write on it or read it. Since literacy and scribal training were prerequisites for obtaining a government office, officials from the Old to the New Kingdom frequently depicted themselves as scribes. The image became rare in the first millennium BC and virtually disappeared after the beginning of the Twenty-sixth Dynasty. The pose is a male one only, because women could not hold government office.

At the beginning of the Middle Kingdom a new pose was introduced for elite men. The subject is shown sitting on the ground with his knees drawn up to his chest underneath a robe that is stretched tight over his legs and body. The cuboid shape of the body has led to the term 'block statue' for this type of pose. Block statues remained popular for the next two millennia, becoming the most frequent type of statue in the Late and Ptolemaic Periods (figure 28). The amount of modelling and detail vary according to period. Sometimes only the head protruded. At other times the hands or feet appeared, or the arms were shown crossed on top of the 'block'. The smooth surface of the 'block' provided an ideal

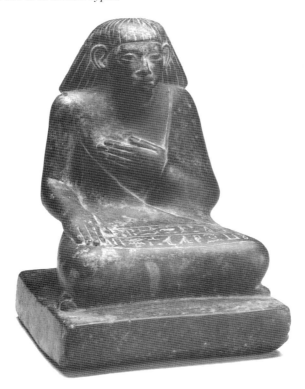

29. Statuette of the official Khnumhotep, cross-legged with a long cloak pulled over his knees, basalt, Twelfth Dynasty, height 19 cm. (Courtesy of the Metropolitan Museum of Art, New York, Bequest of Mrs H.O. Havemeyer, 1929. The H.O. Havemeyer Collection.) (29.100.151)

space for inscriptions and, especially in the Third Intermediate Period, for incised figures and scenes. The pose rarely occurs in groups or in the depiction of women and is not used for divine or royal figures. Although block statues have been found in tombs, the majority were placed in temples.

In the later Twelfth and Thirteenth Dynasties elite men adopted yet another pose. The subject is shown seated cross-legged on the ground with a long robe tucked tautly around the legs (figure 29). This statue type had a fairly short lifespan, although it was occasionally revived at later periods.

Kneeling statues showing elite men became common in the Eighteenth Dynasty. Those holding stelae inscribed with hymns to the sun were placed over entrances to tomb chapels and depict the owner of the chapel (figure 2). Others, usually intended for a temple context, presented ritual items, most commonly a shrine (*naos*) holding a divine statue, but also divine emblems such as the rearing cobra associated with the

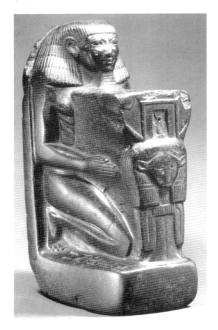
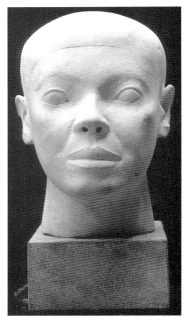

30. (Above left) Kneeling statuette of the official Senenmut, porphyritic diorite, Eighteenth Dynasty, reign of Hatshepsut, height 22.5 cm. (Courtesy of the Metropolitan Museum of Art, New York, Bequest of George D. Pratt, 1935.) (48.149.7.)

31. (Above right) Reserve head, limestone, Fourth Dynasty, mastaba tomb G4440 at Giza, height 30 cm. (Harvard University – Museum of Fine Arts Expedition. 14.719. Courtesy, Museum of Fine Arts, Boston. Reproduced by permission. © 2000 Museum of Fine Arts, Boston. All rights reserved.)

harvest goddess Renenutet, or the *sistrum* (rattle) sacred to the goddess Hathor (figure 30). These temple statues continued to be made during the Late and Ptolemaic Periods.

For a brief time in the Fourth Dynasty images consisting only of a head and neck, without a body, were made in the royal workshops for members of the king's family and high officials (figure 31). They were usually made of limestone and today are known as 'reserve heads', from the hypothesis that they were meant to act as substitutes if the actual head of the deceased was damaged. Of the thirty or so that are known, virtually all of them come from Giza and were found in tomb shafts associated with solid stone mastabas that had no interior chapel or place for statues, in contrast to mastabas at other sites. When solid mastabas at Giza gave way to those with an interior chapel and space for complete statues, reserve heads were no longer produced.

4
Context and function

Statues of deities

The most important part of any temple was the cult statue in which the deity of the temple became manifest. This statue was placed in the sanctuary – the most sacred and protected part of the temple – inside a shrine. The doors of the shrine, which were opened to reveal the deity during the performance of ritual, were called 'the doors of heaven'. They acted as an interface between the normal dwelling place of deities outside the human world and the temple, enabling the deity to enter the temple and be present at the ritual. The importance of divine statues was such that the making of new statues was regularly mentioned in the royal annals of the Early Dynastic Period and Old Kingdom.

Today few cult statues survive. The descriptions we have of them in texts make clear the reason why. They were made of gold and silver, inlaid with precious stones such as lapis lazuli and turquoise, and almost all have long since been melted down for their metal and their inlays reused. Some were undoubtedly made of cast metal. Others may have been made of wood and gilded or covered with sheets of gold and silver. The materials were highly significant for the Egyptians, apart from their value. Gold was the flesh of the gods, silver their bones, and lapis lazuli their hair. These substances were thought to be solidified light from the celestial bodies that manifested the deities in the heavens. The resulting statue replicated the proper form of the deity, thus providing a physical and recognisable body for this being. Although temples were usually dedicated to one main deity, other deities could also reside there as guests, manifest in their own statues.

At festivals, cult statues were carried in procession out of the temple in sacred boats. The cabin of the boat formed the shrine for the statue, which remained hidden inside it. The boats were made of fine-quality imported wood sheathed in gold and silver. The prow and stern were formed into heads representing the deity within – for instance, a falcon's head for the falcon god Horus, or a ram's head for Amun, the god of Thebes – and adorned with necklaces, pectorals and collars of precious metals and stones.

In addition to the cult statues in the sanctuary, many other images of deities were dedicated by the king within temples (figures 3, 14, 40 and 41). These were usually on a larger scale and made of stone. Although few large-scale images of deities have survived from the Early Dynastic Period and the Old and Middle Kingdoms, colossal statues of the ithyphallic god Min stood in the Protodynastic temple of the god at Koptos.

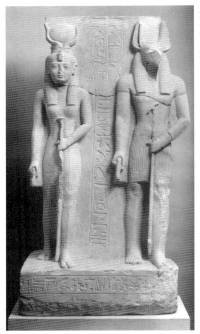

32. Statue group of the deities Wepwawet and Isis-Hathor, limestone, Nineteenth Dynasty, tomb of the official Saaset at Asyut, height 129 cm. (Courtesy of the Metropolitan Museum of Art, New York, Rogers Fund, 1917.) (17.2.5)

In the Late and Ptolemaic Periods it became a common custom for visitors to temples to present bronze votive statues of deities (figure 13). Most of the images were mass-produced and uninscribed, but those specially commissioned carried the name of the donor. Such statuettes provided a link between the dedicator and the deity.

The tomb of Tutankhamun contained a series of small divine statues, made of wood covered with sheet gold, wrapped in pieces of linen, and placed in small shrines. It seems probable that such statues were standard for royal burials of the New Kingdom, but by the time of the royal burials at Tanis in the Twenty-first and Twenty-second Dynasties they were no longer included.

Statues of deities were not commonly placed in elite tombs during the Old and Middle Kingdoms and the Eighteenth Dynasty. During the Ramesside period the situation changed and free-standing and rock-cut images occurred (figure 32). In some tomb chapels, the statues forming the focal point for the performance of ritual represented deities instead of the deceased, as in earlier times. Taken in conjunction with changes in tomb-chapel decoration, it seems that the chapel was now regarded as a private temple for the deceased and his family, in which they could

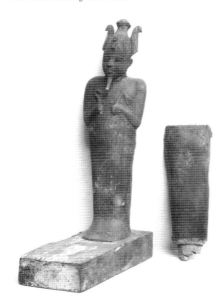

33. (Left) Standing statue of Osiris for holding a Book of the Dead, sycamore wood with a coniferous-wood base, Twenty-first Dynasty, tomb of Gautsoshen at Thebes, height 54 cm. (Courtesy of the Metropolitan Museum of Art, New York, Rogers Fund, 1925.) (25.3.37)

34. (Below) Standing statuette of Anubis, painted wood, Ptolemaic Period, height 42 cm. (Courtesy of the Metropolitan Museum of Art, New York, Gift of Mrs Myron C. Taylor, 1938.) (38.5)

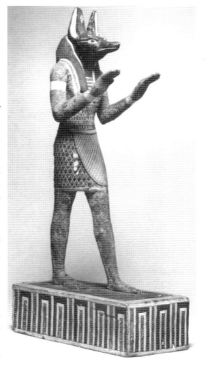

worship the gods after death. During the same period, wooden images of Osiris containing a copy of the Book of the Dead were placed with the body in the burial chamber (figure 33). In the Late and Ptolemaic Periods it became common to place painted wooden statues of funerary deities – Ptah-Sokar-Osiris, Isis and Nephthys as mourners, the four sons of Horus, Anubis – in the burial chamber to help the deceased make a successful transfer to the afterlife (figure 34).

Statues of the king

Statues of the king were placed in royal funerary complexes and in temples but rarely in non-royal burials. At Abydos, it appears that there was

an enclosed room for a statue (*serdab*) in the tomb of the First Dynasty king Den. A small ivory statuette of a king from Abydos may have been associated with a royal burial. Fragments of statues of the king from the Third Dynasty Step Pyramid complex of Djoser at Saqqara show that originally the complex contained a considerable number of royal statues. Today, the best-preserved is a seated limestone statue, now in the Cairo Museum, that was placed in a *serdab* on the north side of the pyramid. The statue faced north and two holes at eye level in the front wall allowed the king's *ka*-spirit, manifest in the statue, to look out at the area in front of the *serdab* where the ritual presentation of offerings and burning of incense for the benefit of the royal *ka* took place.

After the Third Dynasty the rectangular Step Pyramid complex was replaced by a linear complex in association with a true pyramid. This complex consisted of a valley temple at the eastern end, which was joined by a causeway to a pyramid temple situated on the eastern side of the actual pyramid, which formed the western end of the complex. Statues of the king were placed in the valley and pyramid temples (figure 1). Besides being recipients of offerings and ritual performance, they embodied the king in his role as cosmic ruler and depicted his relationship with Egypt's deities.

In the New Kingdom tomb of Tutankhamun, situated in the Valley of the Kings at Thebes, small, gold-covered wooden statues of the king were placed in sealed shrines along with the similarly made divine statues. These were probably standard for all New Kingdom royal tombs, and images of similar statues are depicted on the walls of the tomb of Seti II of the Nineteenth Dynasty. In addition, two life-sized wooden statues of the king covered in black resin and gold foil guarded the sealed entrance to Tutankhamun's burial chamber. Statues similar to the last, although much less well preserved, have also survived from other royal tombs.

In the New Kingdom, the king's burial in the desert, in what is now known as the Valley of the Kings, was separated from his funerary temple, which stood at the edge of the desert where it meets the cultivation. The king merged with the Theban god Amun to produce a specific form of the deity that was worshipped in the temple. Statues of the king of all sizes and types were placed throughout the temple (figure 17 and cover). After the New Kingdom, the royal funerary complex changed entirely. Instead of being constructed in the desert, royal tombs were now built within the main temple enclosure of the city where the king had his residence, or from which the royal family originated. It is not clear if royal statues were associated with royal funerary complexes after the New Kingdom, but there seems to have been none obviously associated with the royal burials of the Twenty-first and Twenty-second Dynasties at Tanis.

State temples from the Early Dynastic Period and the Old and Middle Kingdoms were built primarily of mud brick with some stone elements. Beginning in the Eighteenth Dynasty, these were mostly replaced by monumental stone temples. However, there is evidence from as early as the Second Dynasty that royal statues were set up in temples. The production of a copper statue of the late Second Dynasty king Khasekhemwy is recorded in the royal annals preserved on the Palermo Stone. Two small stone statues of Khasekhem, probably the same king as Khasekhemwy, were found in the temple of Horus at Hierakonpolis. Unfortunately, since they were both discovered in secondary deposits, we have no information about their original locations in the temple. From a similar context came a life-sized statue of Pepi I of the Sixth Dynasty and another smaller figure about a third of the size, both made of sheets of copper. The annals also record the manufacture of other royal statues made of metal during the Old Kingdom.

From the later Old Kingdom to at least the Eleventh Dynasty statues of the king were placed in *ka*-chapels erected within the precincts of state temples, such as the temple of the god Khentamentiu at Abydos and the temple of the goddess Bastet at Bubastis. The image of the king was inhabited by the royal *ka*-spirit that carried the essence of divine kingship from one king to the next. The statue formed the ritual focus in the chapel, being the recipient of offerings and other cult performance, like the cult statue of a deity. Such statues enabled the king's *ka* to be present throughout the land at all times while he was alive and after his death, even though his physical body was restricted to a single location. A decree of Pepi II from Abydos concerns statues of the king, two queens, and the vizier Djau that were set up in the temple of the god Khentamentiu at Abydos. It lays down that each statue was to receive an eighth of an ox and a jug of milk at every festival.

More temple statues representing kings survive from the Middle Kingdom, even though the temples have disappeared, but the vast majority come from the New Kingdom and later. These statues enabled the king to have a perpetual presence in all the temples throughout Egypt, wherever he actually was. The king was a human being who embodied the divine aspect of kingship carried by the royal *ka*-spirit and could thus mediate between humanity and the potentially dangerous realm of the divine. His statues incorporated his various aspects. As bodies for the royal *ka*-spirit, they were focal points of cult, but, as mediators between humanity and the divine, the king stood in a junior relationship with the deities as the performer of their rituals. This is most obvious when the king is shown kneeling and offering (figure 4).

Royal statues frequently related the king to deities in other ways too. Sometimes the king is associated with a deity, as, for example, in statues

with the shrouded mummiform pose of Osiris, or those made of stones such as red granite or quartzite, which were associated with the sun god. Other statues show the king together with one or two deities. Sometimes the figures are on the same scale, and sometimes the king is smaller and visually under the protection of the deity (figure 35).

From the Old Kingdom the king appears as a sphinx with a lion's body and human head (figure 21). In its recumbent form the sphinx seems to have had a protective function and pairs were placed to guard temple entrances. These developed into the avenues of sphinxes, known from the New Kingdom onwards, that lined the approaches to temples and processional ways. The great pylon gateway at the entrance of the temple represented the horizons of the sky where the sun rises and sets. The paired images of the king as sphinx incorporated the form of the two lions that guard the horizon. The lion is also a symbol of strength and ferocity appropriate to the king.

35. Head of King Tutankhamun from a statue of the king and a god with the god's hand resting on the king's head, limestone, Eighteenth Dynasty, height 15 cm. (Courtesy of the Metropolitan Museum of Art, New York, Rogers Fund, 1950.) (50.6)

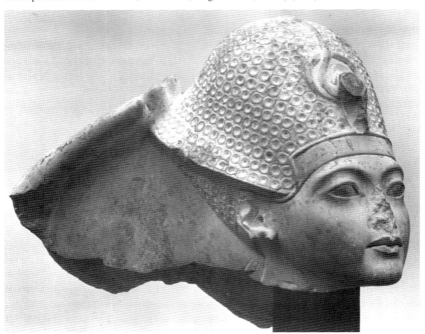

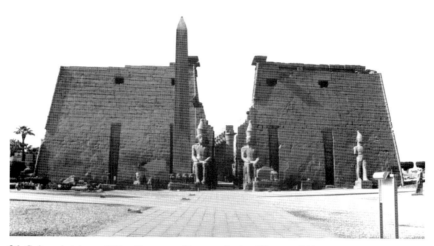

36. Colossal statues of King Ramesses II, granodiorite, Nineteenth Dynasty, temple of Luxor at Thebes. (Author's photograph.)

In front of the pylon itself were often placed colossal seated or standing statues of the king (figures 12 and 36). These are sometimes specifically identified by their texts as *ka*-statues of the king – places where the royal *ka*-spirit dwells. In addition to impressing and overawing viewers with the power of the king, they guarded the temple entrance and protected the pure sacred space inside from the polluting mundane world outside. They were also focal points of cult in their own right, receiving offerings and worship, so that they would act as intermediaries between people who had access only to the less sacred outer parts of the temple and the inaccessible deities inhabiting the sacred interior parts.

Small standing or kneeling images of the king made of metal – bronze, silver or gold, with the least valuable bronze having the best survival rate – were often attached to items of ritual furniture such as sacred barks, offering-tables and censers (figure 8). These depicted the king as the perpetual performer of the cult for the deities at all times and on all occasions. In the Third Intermediate and Late Periods, metal images of the king may also have been presented as votive offerings.

During the reign of Akhenaten, small statues of the king were placed in domestic shrines located in houses and gardens at the king's new capital city of Akhetaten, now known as Amarna, where they formed the focal point for the ritual performed there. It is possible that similar statues of Akhenaten's father, Amenhotep III, had the same function. The divine essence of the king manifest in the statues was worshipped

in its own right but also acted as a link between the human and divine worlds.

Statues of the elite in tombs

In the Early Dynastic period and the Old Kingdom, statues of elite officials and their wives were exclusively associated with tombs. Here they provided a place that could be inhabited by the *ka*-spirit of the deceased person, so as to receive incense and offerings brought by the living. From the end of the First Dynasty come the fragmentary remains of two wooden statues, two-thirds life size, representing striding male figures, found in tomb 3505 at Saqqara. During the Old Kingdom, tomb chapels, which only the upper elite could afford, were mainly free-standing but they could also be rock-cut. In both cases the actual body was placed in a burial chamber at the bottom of a shaft cut into the ground, which was sealed after burial. Above the shaft was the tomb chapel, which remained accessible. This was where funerary priests and living family members brought offerings and performed the rituals for the deceased. In the Old Kingdom, these centred on the false door linking the realms of the dead and living that was placed on the west wall of the offering-chamber. Behind the false door, there was often an enclosed room (*serdab*) linked to the tomb chapel by a small slot in the wall and containing the statues of the deceased and his family. In chapels where the *serdab* was not behind the false door, it formed a separate ritual focus. In the Fifth Dynasty mastaba of the official Ti, the relief decoration on either side of one of the *serdab* slots shows two men burning incense, reflecting the actual ritual performed there. In rock-cut tomb chapels, statues were often carved out of the walls rather than being hidden in a *serdab*. During the later Sixth Dynasty, fewer and fewer tomb chapels were built, so that tombs consisted of just the shaft leading to the burial chamber. Statues were placed in the shaft or more usually in the burial chamber itself.

In the Middle Kingdom, tomb chapels were once more built for the upper elite. The focal point of the funerary ritual was now a rock-cut or free-standing statue of the deceased in a shrine or niche placed at the back of the chapel on the central axis. Statues of other family members, such as the deceased's wife, could be included (figure 37). For the less wealthy, who had no tomb chapel, statues – often small and of mediocre quality – were placed in the burial chamber.

The famous rock-cut Theban tomb chapels of the New Kingdom continued the Middle Kingdom tradition of focusing on rock-cut or free-standing statues. The basic shape of the chapels was that of an inverted 'T', in front of which lay an open court. The statue niche or shrine was placed on the back wall at the end of the stem of the 'T'. The

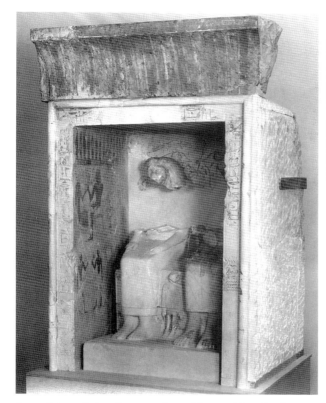

37. Shrine with statues of the official Amenemhat and his wife Neferu, limestone, Middle Kingdom, tomb 202 at Thebes, height 134.5 cm. (Courtesy of the Metropolitan Museum of Art, New York, Rogers Fund and Edward S. Harkness Gift, 1922.) (22.3.68)

ka-spirits of the deceased could manifest in the appropriate statue and receive the offerings and other benefits of the ritual performed by their living relatives. The decoration of the statue niche often showed images appropriate to its function, such as the deceased tomb-owner seated before a table of offerings or rows of offering-bringers.

A kneeling statue of the tomb-owner holding a stela was often put in a niche cut either into the façade above the chapel entrance in the Eighteenth Dynasty or, by the Nineteenth Dynasty, into the small pyramid that now topped the tomb chapel. Whatever the actual orientation of the tomb, which depended on the orientation of the cliff face into which it was cut, the chapel was ritually regarded as facing east towards the sunrise. The stela held by the statue was inscribed with a hymn to the sun on behalf of the deceased, who hoped to spend the afterlife in the entourage of the sun god accompanying him on his daily journey across the sky (figure 2).

At Saqqara, the necropolis of Memphis, many New Kingdom tombs were free-standing. Large tomb chapels imitated the form of a temple

Egyptian Statues

38. Standing statue of an elite woman, Tey, ebony, Eighteenth Dynasty, height 24 cm. (Courtesy of the Metropolitan Museum of Art, New York, Rogers Fund, 1941.) (41.2.10)

with a monumental entrance, open court, colonnaded court and a cult room and, like temples, contained a number of statues. The commonest are seated pair statues showing the tomb-owner and his wife, followed by statues showing the tomb-owner kneeling holding a *naos* (shrine), divine image or offering-table. Block statues of the tomb-owner have also been found. Although few standing statues have survived, they are often shown in the reliefs of these tomb chapels and seem to have flanked doorways. Other statues were placed around the colonnaded courts. Surprisingly, no evidence has been found of statues in the cult room, which was occupied instead by one or more stelae.

In addition to stone statues from tombs, small wooden statues, depicting male or female standing figures, are also known from Thebes, Memphis and elsewhere (figure 38). A few were found *in situ* placed with other grave goods in burials that had no chapel, and it may be that wooden statues were most commonly made for this type of burial.

After the New Kingdom, changes in burial practices meant that for the Third Intermediate, Late and Ptolemaic Periods very few tomb statues were made. Instead, statues were dedicated in temples even though they had funerary functions.

Statues of the elite in temples

In the Early Dynastic Period and most of the Old Kingdom, elite statues were basically confined to the tomb and had no place in temples, where statues only of deities and the king were set up. The decree of Pepi II of the later Sixth Dynasty (see page 35) shows that the vizier Djau, brother of two queens of Pepi I, had a statue set up in the temple of Khentamentiu at Abydos. Another royal decree, this time of the Eighth Dynasty, refers to a *ka*-chapel of the vizier Shemai in the temple

precinct of the god Min at Koptos, the *ka*-chapel undoubtedly containing a statue of Shemai. A further decree from the next king to Shemai's son, the vizier Idi, refers to 'your statues, your offering-tables, your *ka*-chapels … which are in any temple or any temple precinct'. Clearly, by the end of the Old Kingdom, high-ranking officials were placing their statues in temple areas, and during the Middle Kingdom it became increasingly common for the male elite to dedicate their statues in other places besides tombs.

The necropolis of Abydos, where the kings of the First Dynasty had been buried, became the centre in Upper Egypt for the cult of Osiris, ruler of the underworld. A temple was built for him, and every year at his festival his death and resurrection were celebrated by a great procession that carried his statue from the temple to his supposed tomb and back. In order to be associated with the deity, the elite of the Middle Kingdom built small memorial chapels near where the processional route left the temple. In the chapels they placed stelae and statues to enable the owner to be eternally present at the cult centre of the god whose favour was essential for a successful afterlife, and to celebrate his triumphal resurrection during his festival.

A more local phenomenon occurred on the island of Elephantine at Aswan on the southern border of Egypt. An official of the area called Heqaib, who had lived during the Old Kingdom, had been deified during the First Intermediate Period and a shrine was set up, where his cult was celebrated. It was renewed at the beginning of the Twelfth Dynasty by the official Sarenput I, who set up statues of himself and his father. Over the course of the Twelfth and Thirteenth Dynasties, subsequent officials of the area set up shrines containing their own statues, in front of which were placed offering-tables for the presentation of offerings and libations.

Elsewhere elite officials placed their statues in the outer, less sacred areas of state temples. In the tomb chapel of the high official Khnumhotep II at Beni Hasan, a scene shows a statue of Khnumhotep being transported in a shrine, escorted by priests, dancers and Khnumhotep himself, with a caption that says: 'accompanying the statue to the temple'. Setting up a statue in a temple formed a link between the donor and the deity of the temple and allowed the donor to have a perpetual presence in the temple. Although the statue might be set up in the owner's lifetime, it continued to function after he was dead, so that in effect it became a funerary statue.

The mechanism for dedicating a statue in a temple is not clear, but the privilege would seem to have been limited to high-level officials. Sometimes the inscription on a statue states that it was given as a favour of the king, as in the case of a statue representing the treasurer and

steward Gebu, which was placed in the temple of Amun at Karnak. To possess a temple statue was to display status amongst one's peers. The statue itself received a portion of offerings presented in the temple. In another text in his tomb chapel at Beni Hasan, Khnumhotep II says: 'I accompanied my statues to the temple and I arranged for their offerings for them.' There is evidence that such offerings were provided for through a formal contract between the temple priesthood and the owner of the statue, by which the latter made an endowment to the temple in return for offerings being given to the statue.

By the New Kingdom, elite male officials were freely dedicating statues of themselves in the major state temples (figure 30). Some of them even carry texts offering to intercede with the deity of the temple in return for offerings. One such text is specifically addressed to women and offers to intercede on their behalf with the goddess Hathor to obtain a good husband for them. By contrast, few statues of women were placed in temples, and almost all female statues come from tombs.

Since most statues in the Third Intermediate Period and the Late Period were dedicated in temples, they almost all represent men, except for statues of the 'god's wife of Amun', who was a royal priestess in the cult of Amun at Thebes, and women in her entourage. During the Ptolemaic Period, even though statues were still placed mainly in temples, more images of women are found, although in smaller numbers than those of men.

Audience

Despite the central role played by statues in the religious and funerary cults carried out in temples and tomb chapels, human access to most of these images would have been strictly limited, although restrictions would have varied according to where the statue was set up. Within a temple, the least accessible statues would have been the cult images kept sealed in their shrines deep within the temple. Only purified priests carrying out the rituals of the temple would have seen these statues after they had been made functional through the opening of the mouth ritual. When the statues were carried out in public procession in their sacred boats, most were concealed within a shrine, so they were not actually visible to the people lining the processional route. In fact, their beauty was primarily designed for the deity and not for appreciation by any human viewer.

Statues in the less restricted outer parts of the temple would have had a larger human audience. Letters from the Twentieth Dynasty show that it was customary, at least for the elite, to go and pray in the outer courts of temples, where they would have seen the divine, royal and elite statues set up in this area. However, most visible in a temple would

have been the colossal *ka*-statues of the king set up in front of the temple entrance pylon, which were objects of cult in their own right (figure 36). Numerous small stelae relating to the cult of the four *ka*-statues of Ramesses II that stood in front of the temple at his Delta city of Pi-Ramesses show male and female worshippers adoring one of the four statues.

Just as temples were restricted in their access, so too was the king's funerary complex, where the cult of the deceased king was performed by a limited number of purified priests. Although many of the royal statues found in this context impress by their beauty, large size, and representation of power and regal authority, they were never intended as propaganda to overawe the general populace, for the population as a whole had no access to them. Similarly, statues in elite tomb chapels were not intended for general viewing, but to provide physical forms for the deceased when they entered this world, so that living relatives and funerary priests could interact with them through the performance of the funerary rituals.

5
The ideal image and changing styles

Since the primary function of formal statues was to provide a non-physical being with an appropriate physical body in which to manifest itself, this body had to be recognisable – both to the being and to the viewer – as the proper body for that being. The statue had to reflect the category of being – divine, royal, elite – and identify the individual being it was intended for. Categories were distinguished by their insignia and costume. Individual identity was most clearly secured by inscription. Sculptors were aiming to produce neither an exact likeness incorporating the distinguishing features and blemishes of an individual, nor a psychological dimension, even when the image was ultimately based on the actual features of the subject. Instead, the intention was to produce an ideal image that reflected the identity and role of the subject portrayed.

The king was recognisable by his various crowns and sceptres and by his dress, such as the centrepiece worn over the kilt and the bull's tail

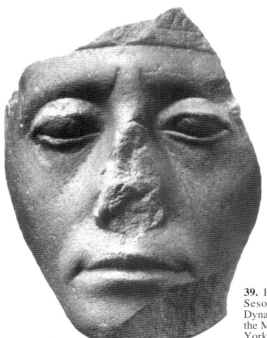

39. Fragment from a statue of King Sesostris III, quartzite, Twelfth Dynasty, height 16.5 cm. (Courtesy of the Metropolitan Museum of Art, New York, Carnarvon Collection, Gift of Edward S. Harkness, 1926.) (26.7.1394)

40. Head from a statue of the god Amun, granodiorite, Eighteenth Dynasty, height 52.1 cm. (Courtesy of the Metropolitan Museum of Art, New York, Rogers Fund, 1907.) (07.228.35)

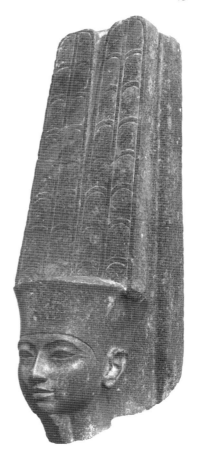

hanging behind him from his belt. His face was normally youthful and his body vigorous (figures 4, 5, 8, 12, 17, 19 and 20). However, individual kings do not all look the same. Although the features are idealised to produce a fittingly regal image, they are often recognisable as belonging to a particular king and may have been based on actual appearance. One of the most unusual and distinctive royal images belongs to Sesostris III of the later Twelfth Dynasty with his heavy-lidded, bulging eyes and thin-lipped mouth. In many instances, his face is not youthful but mature, or even aging, with bags under his eyes and deep lines running between his nose and the corners of his mouth (figures 21 and 39). Interpretations of this image range from seeing the king as a care-worn ruler on the one hand to casting him as a tyrannical despot on the other. It is impossible now to know exactly what the image was intended to convey, although one might suggest that it was meant to imply the wisdom of maturity. It should be noted that the king's body is shown as youthfully vigorous on all his statues and does not change to match his mature, even aging, facial image.

Images of deities in human form were given perfect youthful bodies and faces, and their features often reflected the image of the reigning king (figure 3). Other deities were depicted with a human body and an animal head (figures 14 and 34). Deities were distinguished visually by their insignia, such as the two tall falcon feathers of Amun (figure 40), the double crown of Atum, the *atef*-crown of Osiris (figures 13 and 33), or by their animal heads, such as the falcon head of Horus, the cow head of Hathor (figure 41), and the lion head of Sekhmet (figure 14).

41. Head from a statue of a cow goddess, probably Hathor, porphyritic diorite, Eighteenth Dynasty, probably reign of Amenhotep III, height 52 cm. (Courtesy of the Metropolitan Museum of Art, New York, Rogers Fund, 1919.) (19.2.5)

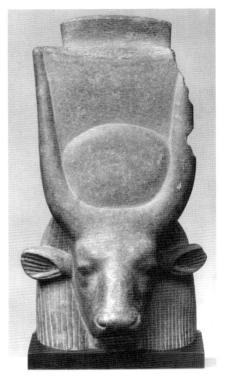

Statues of the elite depicted the ideal of any given period, which was often related to the royal image. Although specially commissioned statues of the wealthy might reflect an individual's actual features, many statues were bought ready-made from workshops and only given an identity when inscribed or put into a context where the identity was made clear. There were two ideal images used for elite men, one youthful and one mature, which represented different life stages. The first incorporated youthful features and a physically fit body. The second image showed a corpulent body or rolls of fat on the chest. In the Old Kingdom, statues of elite men were often made in youthful and mature pairs (figure 42). The two were also frequently distinguished by costume, with the youthful image wearing a wig and short kilt and the mature one with close-cropped hair and a calf-length kilt. The mature image does not represent aging but rather a particular stage in the life of a successful official who eats well, leads a sedentary lifestyle and has acquired wisdom through experience.

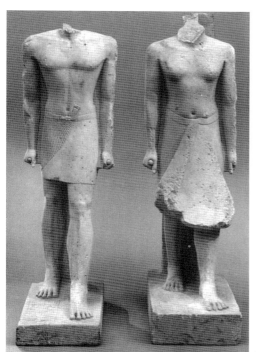

42. (Left) Youthful and mature statues of the official Khnumbaef, limestone, Fifth Dynasty, tomb of Khnumbaef at Giza, height 120.5 and 141 cm. (Courtesy of the Metropolitan Museum of Art, New York, Fletcher Fund, 1964.) (64.66.1 & .2)

43. (Below) Upper part of a statue of an official, schist, Thirtieth Dynasty, height 36.5 cm. (Courtesy of the Metropolitan Museum of Art, New York, Harris Brisbane Dick Fund, 1925.) (25.2.1)

In the late Twelfth and Thirteenth Dynasties, the features of officials represented with a mature image were typically based on the royal model of Sesostris III, described above, and therefore show signs of aging. In the Late Period, the mature image is characterised by a lined face (figure 43). In the past such images have often been interpreted as realistic, but in fact they represent a type and should not be seen as individualising portraits.

44. Standing statuette of the official Tjeteti, wood, Sixth Dynasty, Saqqara, height 42 cm. (Courtesy of the Metropolitan Museum of Art, New York, Rogers Fund, 1926.) (26.2.9.)

There was no equivalent of this mature image for women, who were normally given youthful features and bodies. The contours of the body – the breasts, stomach, pubic region, thighs – were emphasised to signify female fertility and the child-bearing potential of women (figures 22, 24, 38 and 49). Women were valued not only because of their ability to give birth to the next generation and ensure the continuation of the family, but also, since the Egyptians envisioned passage into the next world as rebirth, because they were believed to facilitate this process.

Despite this system of formal and idealising representation, neither the bodily proportions of male and female figures nor the clothes they wore remained unchanged over the three thousand years of pharaonic history. From the Fourth to the Fifth Dynasty, male statues had broad shoulders, a low waist, well-developed musculature and a full face (figure 9). Beginning in the late Fifth and continuing through the Sixth Dynasty into the First Intermediate Period, they changed to have narrow shoulders, a high waist, little or no musculature and a tapering face with large eyes (figure 44). At the beginning of the Middle Kingdom, artists returned to older models for their inspiration and produced statues that once again had broad shoulders, low waists and well-developed musculature. These proportions lasted until the middle of the Twelfth Dynasty, after which shoulders grew narrower, the level of the waist was raised, and musculature disappeared (figure 26). At the same time, far more of the body was covered than before. During the Old Kingdom and earlier Twelfth Dynasty, male figures most commonly wore knee-length or calf-length kilts that left the upper part of the body and the arms bare, except for a collar worn round the neck and bracelets. In the later Middle Kingdom and Second Intermediate Period, standing male figures wore a long calf-length to ankle-length robe that wrapped

round the body under the arms, just below the nipples. Although the arms were not covered, only a small part of the upper torso was left bare and the robe obscures the body beneath it (figure 45). Seated figures were usually wrapped in an enveloping robe or shawl that covered the body from shoulder to ankles. One hand protruded from under the garment in order to hold it securely in place, while the other was placed flat on the chest (figure 46).

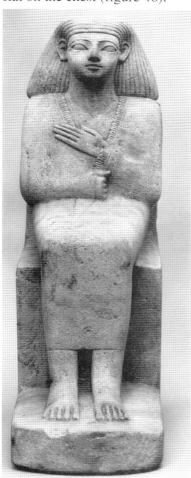

45. (Above) Standing statue of the vizier Yuy, wood, Second Intermediate Period, tomb of Yuy at Thebes, height 89.5 cm. (Courtesy of the Metropolitan Museum of Art, New York, Rogers Fund, 1923.) (23.3.37)

46. (Left) Seated statuette of a man, limestone, Twelfth Dynasty, height 31 cm. (Courtesy of the Metropolitan Museum of Art, New York, Bequest of Theodore M. Davis, 1915. The Theodore M. Davis Collection.) (30.8.73)

At the beginning of the Eighteenth Dynasty, royal sculpture drew on earlier Middle Kingdom statues as a model, producing figures with broad shoulders, a low waist and developed musculature (figure 17). While some statues of officials show similar trends, others exhibit slighter proportions with narrower shoulders and less obvious musculature. From the reign of Amenhotep II onwards, male dress became more elaborate. Around the middle of the dynasty, statues of men began to wear the bag tunic that covers the upper part of the body and tops of the arms. It follows the outline of the body and does not obscure its shape, which is clearly modelled beneath it, but its presence is made clear by the rendering of the sleeves, neckline, and often the cords that tie the garment at the front (figure 23). From the reign of Amenhotep III, the volume of material incorporated into male garments increased, and elaborate pleated

sashes that tied round the waist became fashionable. Male shoulder-length wigs were elaborately dressed in braids and curls, often falling in two layers with the upper one arranged to reveal the lower. By the Nineteenth Dynasty, the lower layer of the wig had lengthened so that it fell down in front of the shoulders as far as the collar bone (figure 47).

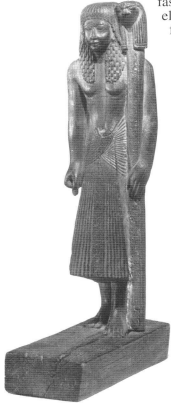

Although there are few non-royal statues surviving from the reign of Amenhotep III's son, Akhenaten, images of the king show a marked change in bodily proportions from what went before. The head and neck are long and thin, the shoulders are narrow, the small of the back is high, and the arms are thin. The swelling belly falls in a fold, while the large buttocks and thighs sit atop short, spindly lower legs (figure 48).

After the death of Akhenaten there was a return to more traditional proportions, which together with the elaborate costume of the later Eighteenth Dynasty formed the basis for male images throughout the rest of the New Kingdom and much of the Third Intermediate Period.

47. Standing statuette of the artist Karo holding a standard, wood, Nineteenth Dynasty, Deir el-Medina at Thebes, height 48 cm. (Courtesy of the Metropolitan Museum of Art, New York, Rogers Fund, 1965.) (65.114)

48. Standing statue of Akhenaten, limestone, Eighteenth Dynasty, Amarna boundary stela A at Tuna el-Gebel. (Author's photograph.)

The New Kingdom style was totally abandoned at the end of the Third Intermediate Period, and sculptors of the Late Period returned to earlier models from the Old Kingdom, Middle Kingdom and early Eighteenth Dynasty. Musculature was again emphasised, together with broad shoulders and low waists (figure 27). Much of the depicted costume returned to the simpler styles of earlier times, with figures frequently wearing only the knee-length kilt.

Female statues were always carefully differentiated from those of men by their bodily proportions and costume. Thus, whatever the male proportions being employed, female figures were normally more slender, with a higher waist and no musculature – all differences based on nature. From the Old Kingdom to the early Eighteenth Dynasty, female figures tend to have fairly small breasts (although there is considerable

variation), a flat stomach and an emphasised pubic region. The standard costume was the so-called sheath dress that covers the body from on or just below the breasts to just above the ankles. Two straps run over the breasts, across the shoulders and down the back. The dress hugs the body, clearly revealing its shape (figures 22 and 26).

During the later Eighteenth Dynasty a fuller figure with a swelling stomach under a clearly marked waist becomes fashionable (figure 49). This develops into the image used to portray Nefertiti and her daughters during the reign of Akhenaten – pronounced breasts, a high, narrow waist above a broad, swelling stomach, and large, curvaceous buttocks and hips. The sheath dress was abandoned and replaced by a long, pleated dress wrapped around the body, often worn together with a shawl that was tied at the front of the body (figures 23 and 38). In two-dimensional representation the dress falls away from the body, which is often revealed beneath it as though the material were transparent. In statues the dress is moulded to the body so that its shape is clearly revealed (figure 49).

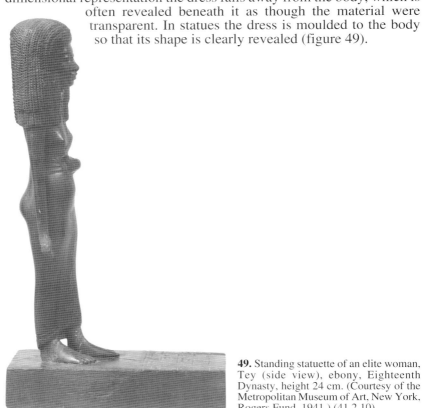

49. Standing statuette of an elite woman, Tey (side view), ebony, Eighteenth Dynasty, height 24 cm. (Courtesy of the Metropolitan Museum of Art, New York, Rogers Fund, 1941.) (41.2.10)

6
Texts and relief decoration

The majority of statues are inscribed, and some include relief decoration on their surfaces. Placing a name on a statue gave the image its individual identity. Some elite statues were, however, uninscribed and one must assume that they acquired their identity from their context, most usually the burial with which they were associated. Others may originally have been placed in a shrine or statue niche that carried identifying inscriptions. The identity of a statue could be changed by deleting the original name and replacing it with a new one. Royal statues were quite often treated in this way (figure 50). Sometimes the name alone was changed; in other cases the statue was recut to bring it into line with images of the king for whom it was now inscribed.

A divine statue not only named the deity portrayed but often also included the name of the king who had dedicated it. The two names were linked because the king was said to be beloved of the deity concerned. The inscription, therefore, not only identified the deity but established and displayed a link between the king and the deity. It signified that the king had fulfilled his duty to provide for the cult of the deity and that the deity acknowledged the king as legitimate ruler.

Statues of the king referred to his cosmic duties and to his relationship with deities. In addition to identifying the king, texts frequently describe the king as being beloved of a deity, usually the deity in whose temple the statue was placed. The sides of the seated king's throne often carry the *sema tawy* symbol representing the union of Upper and Lower Egypt. This consists of a central hieroglyph that means 'to unite/union', around which stems of the plants of Upper and Lower Egypt, the lily and papyrus, are knotted (figure 50). Thus the enthroned king unites the two parts of Egypt in his person. In some cases the motif can be rendered very elaborately. In addition to the *sema* hieroglyph and the two plants of Upper and Lower Egypt, two divine figures representing the two parts of the country may be shown tying the plants. These may be the gods Seth for Upper Egypt and Horus for Lower Egypt, although, because Seth was a somewhat ambivalent figure as a result of his association with chaos, Thoth was often substituted as the Upper Egyptian representative. In other examples the plants are tied by two fecundity figures, personifications of the wealth and fertility of Egypt. One figure wears the Upper Egyptian lily on his head and the other wears the papyrus of Lower Egypt. Such statues were meant to be oriented so that the Upper Egyptian figure was to the south and the Lower Egyptian one to the north.

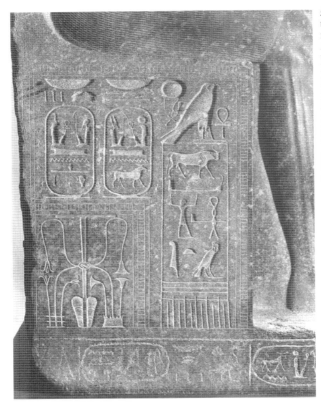

50. Detail of side of throne with *sema tawy* motif from a statue of Amenhotep III usurped by Merneptah, porphyritic diorite, Eighteenth Dynasty, temple of Luxor at Thebes. (Courtesy of the Metropolitan Museum of Art, New York, Rogers Fund and Gift of Edward S. Harkness, 1921.) (22.5.1)

On top of the surface of the statue base, under the king's feet, are frequently carved nine archery bows. These symbolised the traditional enemies of Egypt who represented the forces of chaos that the king must overcome in order to maintain cosmic order (*maat*). This image visually recalls the frequent phrase 'All foreign lands are under your feet/sandals' and shows the king triumphant over his enemies and chaos.

In the Old, Middle and New Kingdoms, images of family members, especially children, were often included in relief on elite statues. During the Third Intermediate Period, two-dimensional images of deities and divine emblems were commonly incorporated into the surface of statues, a trend that continued into later periods (figure 28).

Old Kingdom statues of the elite were mostly inscribed with the titles and names of the people represented. From the Fourth Dynasty, and more commonly in the Fifth and Sixth Dynasties, the owner was

designated as *imakhu*, 'revered one', or *imakhu kher netjer aa*, 'one revered before the great god', phrases that relate to the funerary function of the statue. From the Middle Kingdom onwards, statues also carry the offering formula (*hetep di nesu*) which petitions deities for benefits on behalf of the owner. The formula originally developed in a tomb context on coffins and stelae and invoked the funerary deities Anubis and Osiris. Its use later spread also to temple statues, where the formula often invoked the deities of the temple where the statue was placed and asked for benefits beyond the normal funerary ones. These included entrance to and egress from the temple and a share of the offerings presented on the altar of the deity.

In the Middle and New Kingdoms, some statues of male officials specifically say that they were 'given as a favour of the king', a fact that is recorded because it links the official to the king and thereby enhances his status. The surface of statues began to be used for recording traditional 'autobiographical' texts that cast the official's career into a standard form relating how he successfully fulfilled his duties and moral obligations within society. As time went on through the New Kingdom and Late Period, there was a tendency for texts on statues to increase in length. Male statues also sometimes have the cartouche of the king they served placed on the surface of their body.

The texts inscribed on many statues are today eagerly read by Egyptologists who wish to glean all the information they can from them, but who was originally meant to read them? First we have to remember that only a small group of the population – elite male officials – were literate. The majority of ancient Egyptians, male and female, would have been illiterate. Although there is some evidence of literacy on the part of a few elite women, it is unclear whether elite women as a group were generally literate, sometimes literate, or only rarely literate.

In any case, literacy for an ancient Egyptian meant first and foremost reading and writing the cursive hieratic script written with a brush on papyrus. Although derived from hieroglyphs, at first sight it bears little resemblance to them. Thus, for many literate Egyptians, reading monumental hieroglyphic texts may not have come easily. Furthermore, statues were rarely set up so that the texts would be readily accessible. Those on the sides and back were likely to be concealed by a surrounding shrine or niche, or simply to be invisible because of poor lighting conditions. How many people, passing through the outer precincts of a temple pursuing their own purposes, would have had time to read the often densely written inscriptions on the statues placed there? If relatives or priests were visiting a particular statue in a tomb chapel or temple precinct, presumably they already knew whom it represented. Did someone who could read hieroglyphs recite what was written there for

everyone present or did the text remain silent? In temples, who could even see, let alone read, the texts high up on a colossal statue? Could it be that the texts were meant more for the dead and the deities represented by the statues than they were for the living? Clearly we do not know all the answers to these questions, but it seems safe to say that most texts on statues would have had a very restricted audience among the living. However, the presence of hieroglyphs on a monument was probably prestigious in itself and added to the status of the person portrayed. Furthermore, the content of the texts must have had a potency irrespective of whether there were any living readers or not, since objects which were never meant to be seen by the living once they had been placed in a sealed burial were nevertheless frequently inscribed. We must never forget that, for the ancient Egyptians, the world was inhabited not only by living human beings but also by deities and the dead, and that the latter were a major part of the audience for whom the monuments of ancient Egypt were designed.

7
Conclusion

The basic characteristics of ancient Egyptian formal statues were governed by their function as focal points in cult. Frontality was a fundamental feature from the beginning to the end of the pharaonic period, and its dominance together with the limited poses for formal statues may give the impression that little changed during this time. In fact, new types of statues were introduced from time to time, the context for elite statues moved from the tomb to the temple, and above all there were continual changes in style, proportions and depicted dress.

Outside Egypt, knowledge of ancient Egyptian monumental statues inspired the creation of life-size, and over-life-size, hard-stone statuary by Greek sculptors. Psammetichus I, the first king of the Twenty-sixth Dynasty, brought Ionian and Carian mercenaries to Egypt to help him consolidate his hold on the country, after which Greeks, although strictly controlled, were allowed to settle and trade in Egypt. There, they would have seen monumental hard-stone statues, in contrast to the much smaller limestone or sandstone statues produced until that time by Greek sculptors. Not long after, the first monumental Greek statues, made of marble, which is harder than either limestone or sandstone, appeared. The male *kouroi* of the Greek Archaic Period exhibit frontality and stand with the left leg advanced, the arms held at the sides of the body, and the fists clenched. Clearly the pose is based on that of a typical Egyptian male standing statue.

A story told by the Greek author Diodorus recounted how two Greek sculptors of the mid sixth century BC, one in Samos and the other at Ephesus, each made one half of a statue 'and when they were brought together they fitted so perfectly that the whole work had the appearance of having been done by one man'. The explanation given is that the sculptors got the proportions of the two halves to correspond so exactly by using the standard grid system employed by Egyptian sculptors at that time, suggesting that Greek artists were familiar not only with the form of Egyptian statuary but also with the working methods of sculptors in Egypt. Thus, it seems that the long tradition of Egyptian statue-making helped shape the development of monumental Greek statuary, which in its turn was to have a profound influence on later western artistic traditions.

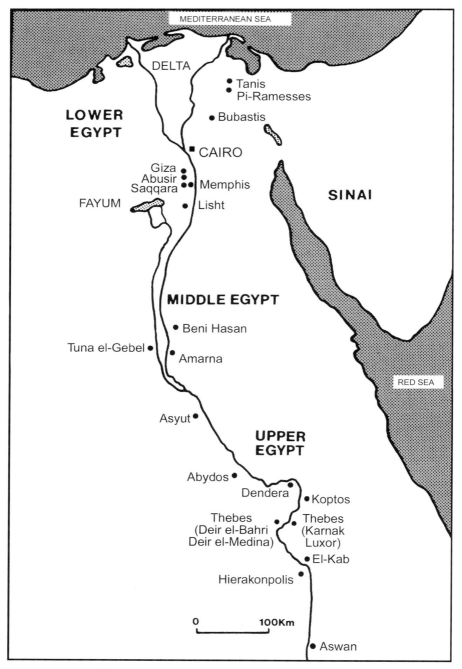

51. Map of Egypt, showing places mentioned in the text.

8
Further reading

Arnold, D. (editor). *Egyptian Art in the Age of the Pyramids*. Metropolitan Museum of Art, New York, 1999. (Excellent exhibition catalogue that includes essays and entries on Old Kingdom statues.)

Borchardt, L. *Statuen und Statuetten von Königen und Privat Leuten*, I–V. Catalogue Général des Antiquités Égyptiennes du Musée du Caire. Reichsdruckerer, Berlin, 1911–36. (Illustrated catalogue of royal and private statues in the Cairo Museum.)

Bothmer, B.V. *Egyptian Sculpture of the Late Period, 700 BC to AD 100*. Brooklyn Museum, 1960. Reprint, Arno Press, New York, 1969.

Daressy, G. *Statues de Divinités*. Catalogue Général des Antiquités Égyptiennes du Musée du Caire. Institut Français d'Archéologie Orientale, Cairo, 1906. (Illustrated catalogue of statues of deities in the Cairo Museum.)

Délange, E. *Catalogue des Statues Égyptiennes du Moyen Empire 2060–1560 avant J.-C.* Editions de la Réunion des Musées Nationaux, Paris, 1987. (Illustrated catalogue of the Middle Kingdom statues in the Musée du Louvre, Paris.)

Eaton-Krauss, M. *The Representations of Statuary in Private Tombs of the Old Kingdom*. Otto Harrassowitz, Wiesbaden, 1984.

Evers, H.G. *Staat aus dem Stein, Denkmäler, Geschichte und Bedeutung der Ägyptischen Plastik während des Mittleren Reichs*, I–II. F. Bruckmann A.-G., Munich, 1929.

Habachi, L. *The Sanctuary of Heqaib*, I–II. Philipp von Zabern, Mainz, 1985. (A well-illustrated publication of a group of Middle Kingdom statues found in the sanctuary of Heqaib on the island of Elephantine. Excellent for observing stylistic changes during this period.)

James, T.G.H., and Davies, W.V. *Egyptian Sculpture*. British Museum Publications, London, 1983.

Josephson, Jack A. *Egyptian Royal Sculpture of the Late Period, 400–246 BC*. Philipp von Zabern, Mainz, 1997.

Koefoed-Petersen, O. *Catalogue des Statues et Statuettes Égyptiennes*. Ny Carlsberg Glyptotek Publications, no. 3, Copenhagen, 1950.

Kozloff, A., and Bryan, B. *Egypt's Dazzling Sun. Amenhotep III and His World*. Cleveland Museum of Art and Indiana University Press, 1992. (Exhibition catalogue that includes important sections on divine, royal and private statues of the reign of Amenhotep III.)

Legrain, G. *Statues et Statuettes des Rois et des Particuliers*, I–III. Catalogue Général des Antiquités Égyptiennes du Musée du Caire. Institut Français d'Archéologie Orientale, Cairo, 1906–25. (Illustrated

catalogue of royal and private statues in the Cairo Museum.)

Linblad, I. *Royal Sculpture of the Early Eighteenth Dynasty in Egypt.* Medelhavsmuseet Memoir 5, Stockholm, 1984.

Lorton, D. 'The Theology of Cult Statues in Ancient Egypt', in M. Dick (editor), *Born in Heaven, Made on Earth: The Making of the Cult Image in the Ancient Near East.* Eisenbraun, Winona Lake, Indiana, 1999.

Malek, J. 'The Saqqara Statue of Ptahmose, Mayor of the Memphite Suburbs', in *Revue d'Égyptologie* 38 (1987), pages 117–37. (Overview of statue types found in New Kingdom tombs at Saqqara.)

Robins, G. *The Art of Ancient Egypt.* British Museum Press, 1997.

Russman, E.R. *The Representation of the King in the XXVth Dynasty.* Brussels and Brooklyn, 1974.

Russmann, E.R. *Egyptian Sculpture, Cairo and Luxor.* University of Texas Press, Austin, 1989.

Russmann, E.R. 'A Second Style in Egyptian Art of the Old Kingdom', in *Mitteilungen der Deutschen Archäologischen Instituts, Kairo* 51 (1995), pages 269–79. (Discusses changes in style that occurred in the late Fifth and Sixth Dynasties in relation to statues.)

Seipel, W. *Gott, Mensch, Pharao: Viertausend Jahre, Menschenbild in der Skulptur des alter Ägypten.* Kunsthistorisches Museum, Vienna, 1992. (Well-illustrated catalogue of an exhibition on divine, royal and non-royal statues.)

Smith, W.S. *The Art and Architecture of Ancient Egypt.* Yale University Press, New Haven and London, third edition 1998.

Smith, W.S. *A History of Egyptian Sculpture and Painting in the Old Kingdom.* Oxford University Press, 1946. Reprint, Hacker Art Books, New York, 1978.

Tefnin, R. *La Statuaire d'Hatshepsout.* Foundation Égyptologique Reine Élisabeth, Brussels, 1979.

Tooley, A.M.J. *Egyptian Models and Scenes.* Shire Publications, 1995. (Treats servant statuettes not covered in the present volume.)

Vandier, J. *Manuel d'Archéologie Égyptienne*, III. *Les Grandes Époques: la Statuaire*, I–II. Éditions A. et J. Picard, Paris, 1958.

Ziegler, C. *Les Statues Égyptiennes de l'Ancien Empire.* Éditions de la Réunion des Musées Nationaux, Paris, 1997. (Illustrated catalogue of the Old Kingdom statues in the Musée du Louvre, Paris.)

9
Museums

Great Britain

Ashmolean Museum of Art and Archaeology, Beaumont Street, Oxford
 OX1 2PH. Telephone: 01865 278000. Website: www.ashmol.ox.ac.uk
British Museum, Great Russell Street, London WC1B 3DG. Telephone: 020
 7636 1555 or 020 7580 1788 (infoline). Website: www.britishmuseum.ac.uk
Durham University Oriental Museum, Elvet Hill, Durham DH1 3TH.
 Telephone: 0191 374 7911. Website: www.dur.ac.uk/orientalmuseum
Fitzwilliam Museum, Trumpington Street, Cambridge CB2 1RB.
 Telephone: 01223 332900. Website: www.fitzwilliam.cam.ac.uk
Liverpool Museum, William Brown Street, Liverpool L3 8EN.
 Telephone: 0151 478 4399. Website: www.nmgm.org.uk
National Museum of Scotland, Chambers Street, Edinburgh EH1 1JF.
 Telephone: 0131 225 7534. Website: www.nms.ac.uk
Petrie Museum of Egyptian Archaeology, University College London,
 Malet Place, London WC1E 6BT. Telephone: 020 7679 2884. Website:
 www.petrie.ucl.ac.uk

Austria

The Vienna Kunsthistorisches Museum, Maria-Theresien Platz, A-1010
 Vienna. Telephone: (+431) 525 24 401. Website: www.khm.at

Belgium

Musées Royaux d'Art et d'Histoire, Avenue J. F. Kennedy, 1040
 Brussels. Telephone: (+32) 2 741 72 11. Website: www.kmkg-mrah.be

Canada

Royal Ontario Museum, 100 Queen's Park, Toronto, Ontario M5S 2C6.
 Telephone: (+1) 416 586 5549. Website: www.rom.on.ca

Denmark

Ny Carlsberg Glyptotek, Dantes Plads 7, DK-1556 Copenhagen V.
 Telephone: (+45) 33 41 81 41. Website: www.glyptoteket.dk

Egypt

Egyptian Antiquities Museum, Tahrir Square, Kasr el-Nil, Cairo.
 Telephone: (+20) 2 575 4267.
Luxor Museum of Ancient Egyptian Art, Luxor.
Nubia Museum, Aswan.

Egyptian Statues

France
Musée du Louvre, Palais du Louvre, F-75041 Paris. Telephone: (+33) 1 40 20 53 17. Website: www.louvre.fr

Germany
Ägyptisches Museum, Staatliche Museen zu Berlin, Bodestrasse 1–3, 1020 Berlin. Website: www.smb.spk-berlin.de

Ägyptisches Museum und Papyrussammlung, Schlossstrasse 70, 14059 Berlin. Telephone: (+33) 34 34 73 37. Website: www.smb.spk-berlin.de

Roemer-Pelizaeus-Museum, Amsteiner 1, 3200 Hildesheim, Niedersachsen.

Greece
National Archaeological Museum of Athens, Patission 44 St, Athens 10682. Telephone: (+30) 1 8217717. Website: www.culture.gr

Italy
Museo Egizio, Palazzo dell'Accademia delle Scienze, Via Accademia delle Scienze 6, Turin.

Netherlands
Rijksmuseum van Oudheden, Rapenburg 28, 2311 EW, Leiden. Telephone: (+31) 71 516 31 63. Website: www.rmo.nl

Russia
Pushkin Museum of Fine Arts, Volkhonka 19, 121019, Moscow.

United States of America
Brooklyn Museum of Art, 200 Eastern Parkway, Brooklyn, New York 11238-6052. Telephone: (+1) 718 638 5000. Website: www.brooklynart.org

Field Museum of Natural History, 1400 Lake Shore Drive, Chicago, Illinois 60605. Telephone: (+1) 312 922 9410. Website: www.fmnh.org

Metropolitan Museum of Art, 1000 Fifth Avenue at 82nd Street, New York, New York 10028-0198. Telephone: (+1) 212 535 7710. Website: www.metmuseum.org

Museum of Fine Arts, 465 Huntington Avenue, Boston, Massachusetts 02115-5523. Telephone: (+1) 617 267 9300. Website: www.mfa.org

University of Chicago Oriental Institute Museum, 1155 East 58th Street, Chicago, Illinois 60637. Telephone: (+1) 773 702 9520. Website: www-oi.uchicago.edu

Walters Art Gallery, 600 North Charles Street, Baltimore, Maryland 21201. Telephone: (+1) 410 547 9000. Website: www.thewalters.org

Index

Page numbers in italic refer to illustrations